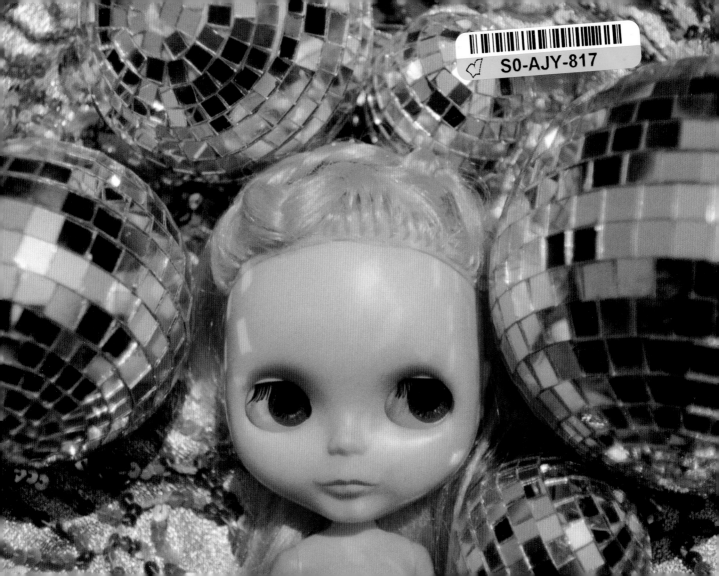

this is Blythe

Photographs by **GINA GARAN**

CHRONICLE BOOKS
SAN FRANCISCO

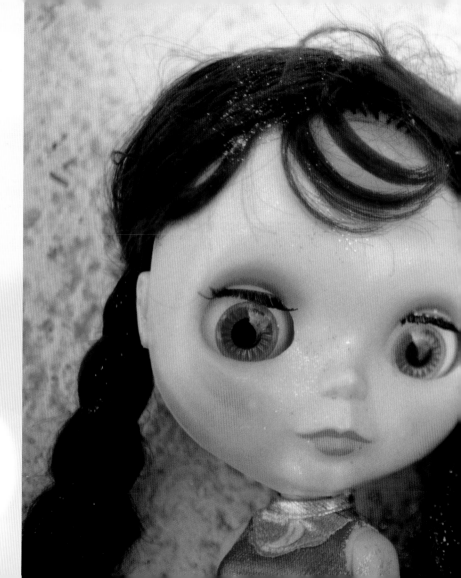

ACKNOWLEDGMENTS

Hugs, kisses, and many thanks to: Ted Ottaviano; Christy Ottaviano; Lily Triant; Michael Economy; Justin Bond; Sammy Jo; David LaChapelle; Luis Nunez; Myk Fisher; John Tiffany; Karen Carpenter; Theda Antrican; Pablo Maldonado; Alkit Pro Camera; Steve Mockus, Alan Rapp, and Jeremy Stout at Chronicle Books; Willie Marin; Lisa and Matthew Sweet; John Cameron Mitchell; Katharyn Pinder; Scott Fichten; Robin Reisman; the gang at Drury Design Dynamics; and my fantastic family!

- -

Library of Congress Cataloging-in-Publication Data:

Garan, Gina, 1964–
This is Blythe / photographs by Gina Garan.
p. cm.
ISBN: 0-8118-2823-9 (pbk.)
1. Photography, Artistic. 2. Character dolls—Pictorial works. 3. Garan, Gina, 1964– I. Title.
TR654.G334 2000
779'.092—dc21 99-052979

Printed in Hong Kong.

Designed by Jeremy Stout

Distributed in Canada by Raincoast Books
9050 Shaughnessy Street
Vancouver, British Columbia V6P 6E5

10 9 8 7 6 5 4

Chronicle Books LLC
85 Second Street
San Francisco, California 94105

www.chroniclebooks.com

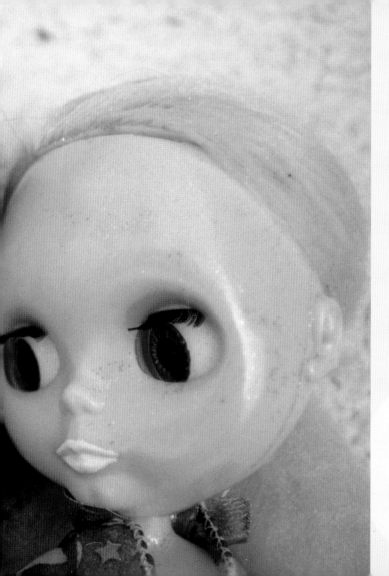

WHEN OUR EYES MET I KNEW INSTANTLY THAT I'D FOUND A KINDRED SPIRIT, A KIND OF "FRIEND." SOME SAY THAT WE TEND TO FALL IN LOVE WITH THOSE WHO RESEMBLE OURSELVES, AND MY FRIENDS SAY BLYTHE AND I DO LOOK ALIKE. BUT THERE WAS SOMETHING MORE COMPELLING THAN JUST LOOKS—THERE WAS AN INNER BEAUTY THAT CHARMED ME. WE WENT ON OUR FIRST PHOTO SHOOT SOON AFTER, AND SO BLYTHE AND I BEGAN OUR STRANGE ODYSSEY.

Blythe was produced for just one year, 1972. As you can see, her most distinguishing feature is her abnormally large head. I think her quirky looks may have had something to do with the fact that she wasn't extremely popular with children. Blythe also has a string on the back of her head that, when pulled, changes the direction and color of her eyes, from blue to orange to green to pink. Blythe's original fashions—twelve in all—included outfits such as "Golden Goddess," "Kozy Kape," "Pretty Paisley," and "Medieval Mood," in addition to four natural hair colors and four fruit-colored wigs (lime, blueberry, lemon, and strawberry).

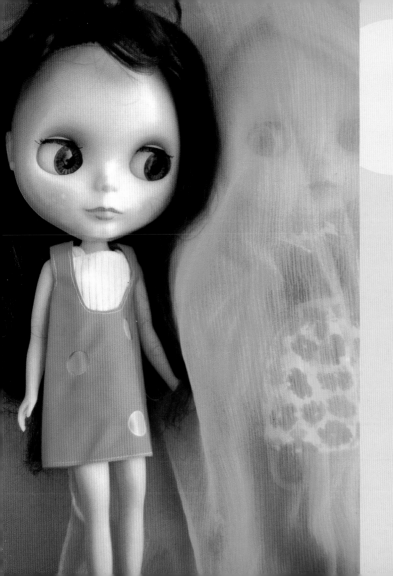

The possibilities for photographing Blythe are endless, but just as she is my muse, she can also be my obsession. I'm constantly searching for props and clothes for her, many of which I've discovered in vintage toy shops and flea markets. When the perfect outfit can't be found, I've been known to whip up a go-go outfit from a pair of glitter panty hose. I also create all of Blythe's hairstyles. A gentle pull of the string is all it takes for the finishing touch, and her expression changes from wholesome to mischievous without moving a muscle. She's a nun, a hippie, a starlet, a tennis player, uptown catching a cab or downtown spacing out, prancing on the beach or telling Santa her secret Christmas wish. Blythe is every woman.

No matter where her travels take her (and I take her everywhere), Blythe is at home in her environment in her own glamorous way. She's traveled all over the world, has lots of celebrity friends, and has even co-piloted a 747. I hope that you enjoy Blythe's photos for what they are, but I also hope, perhaps on a deeper level, that Blythe reminds you to embrace the rare and unique, the beautiful and the funny qualities that are the true essence of who we are.

—*Gina Garan*

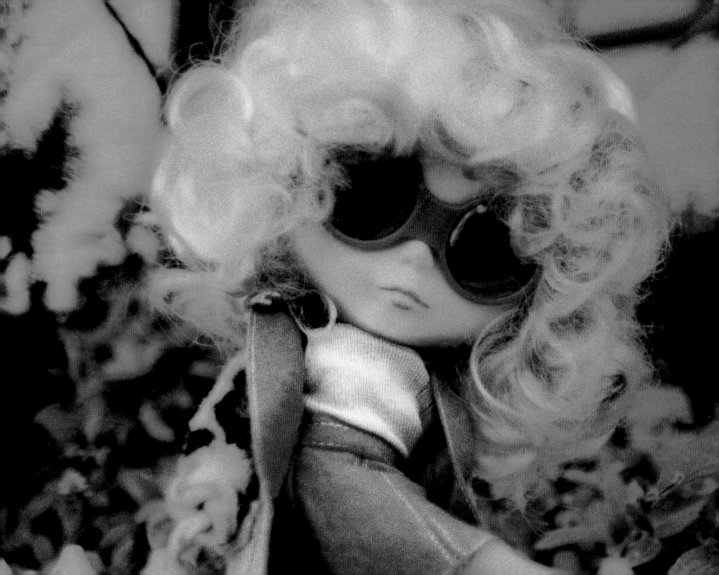

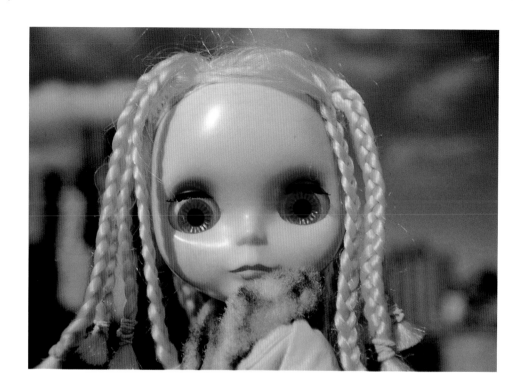

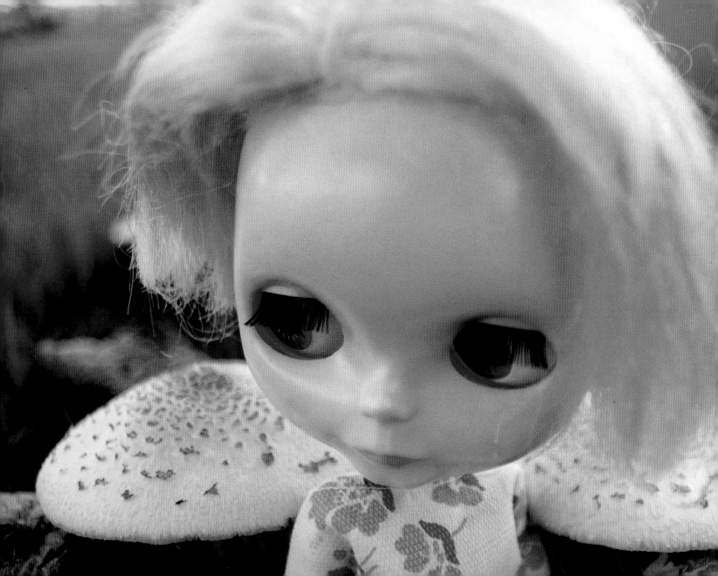

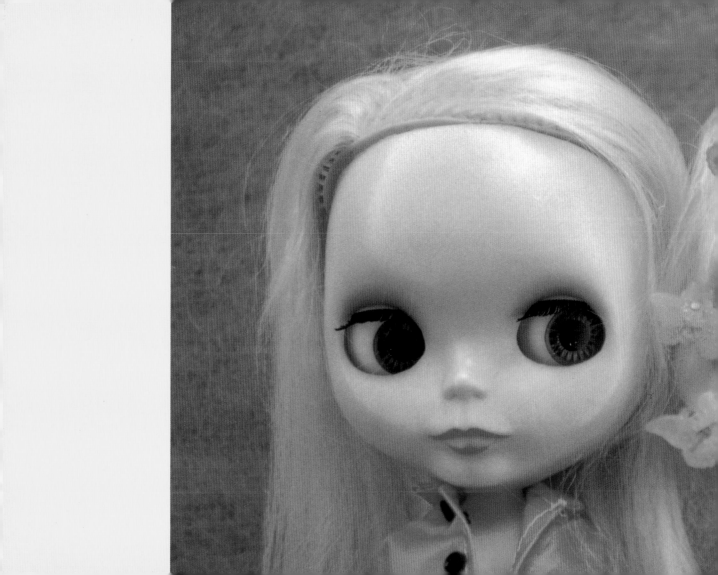

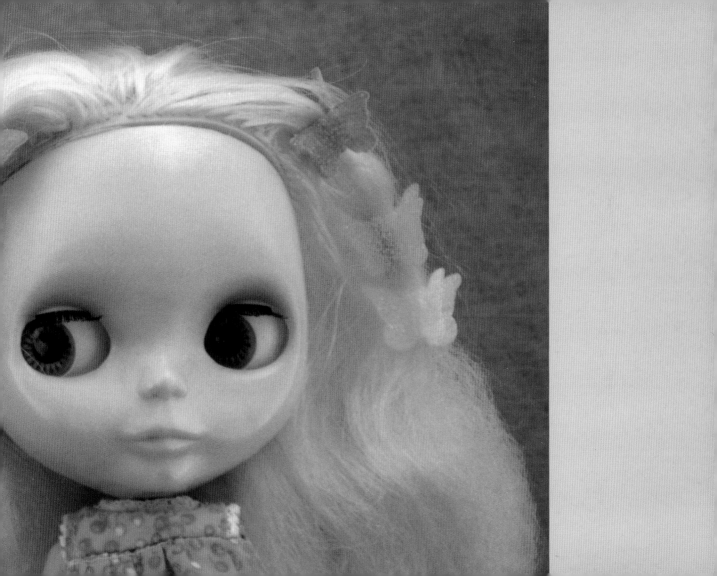

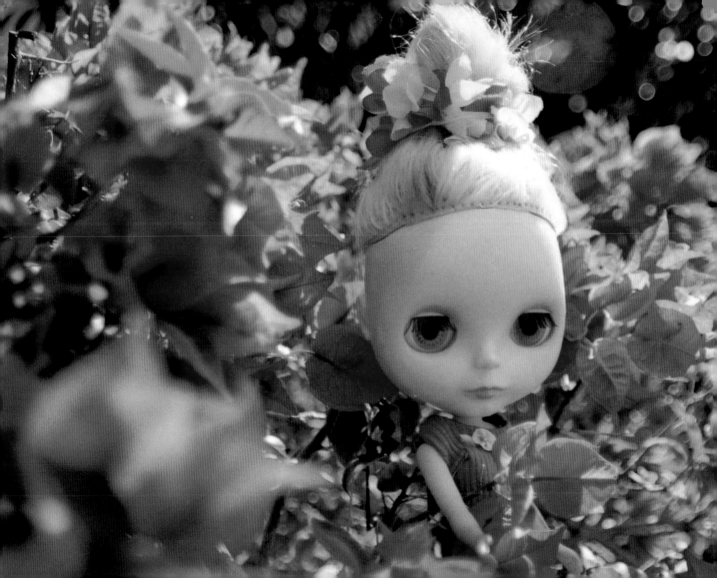

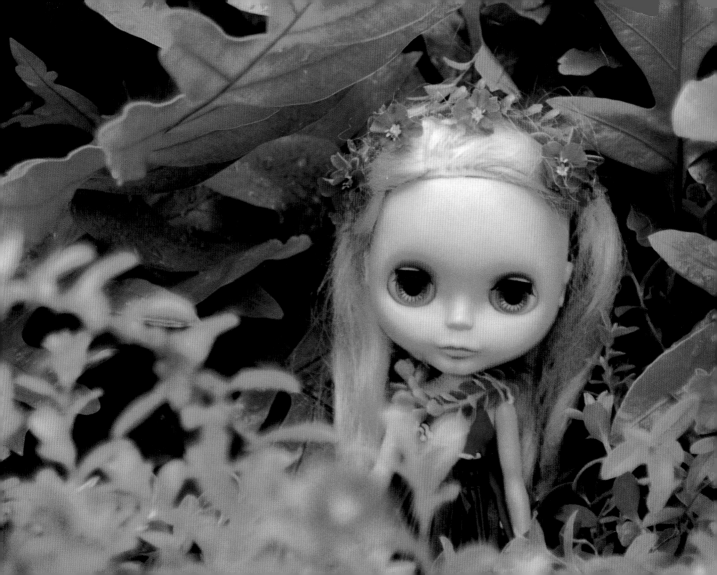

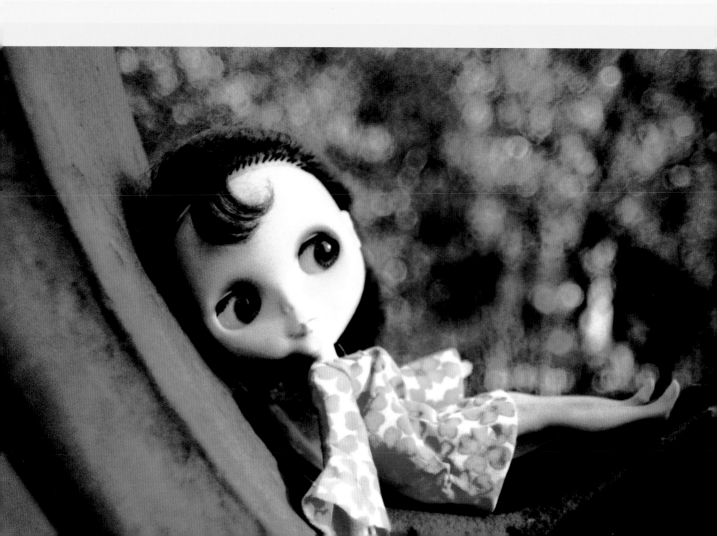

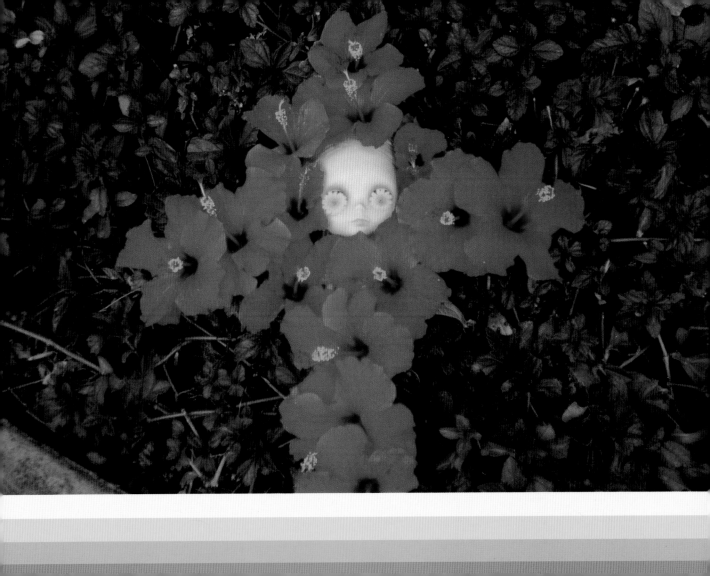

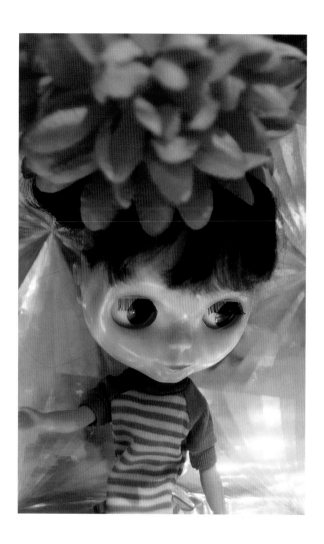

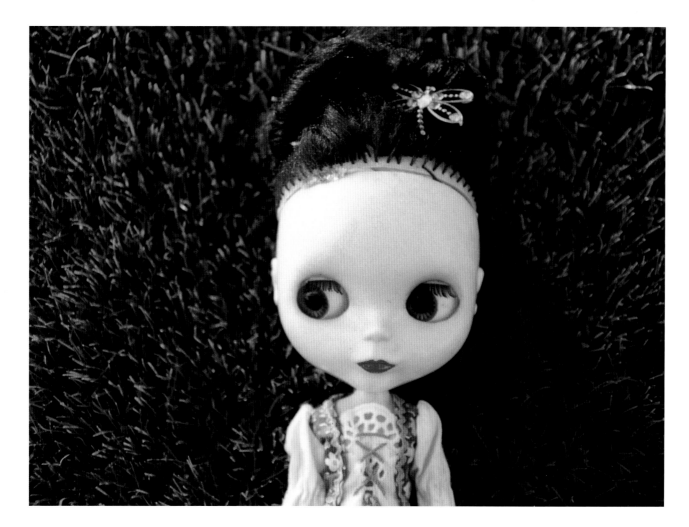

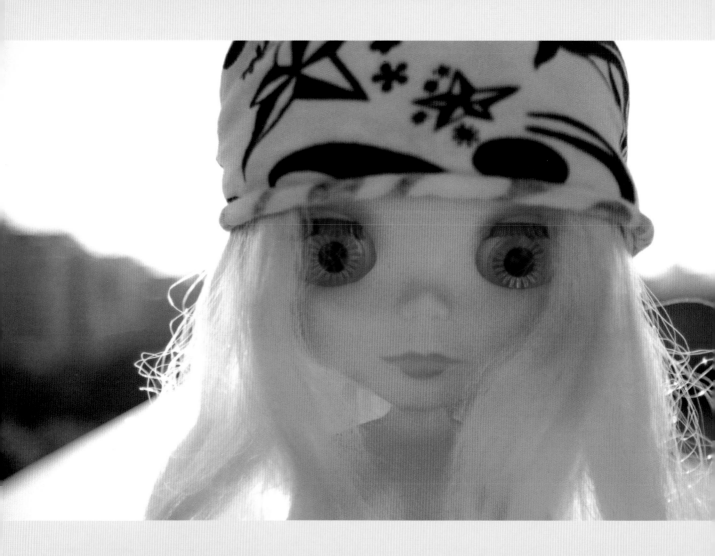

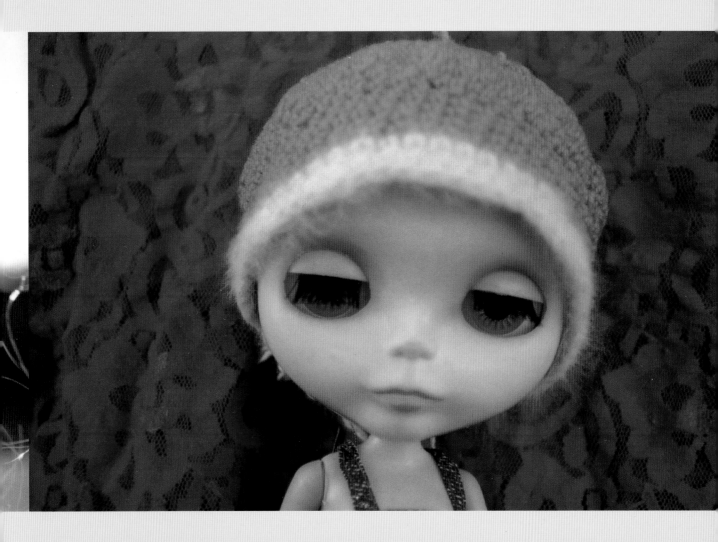

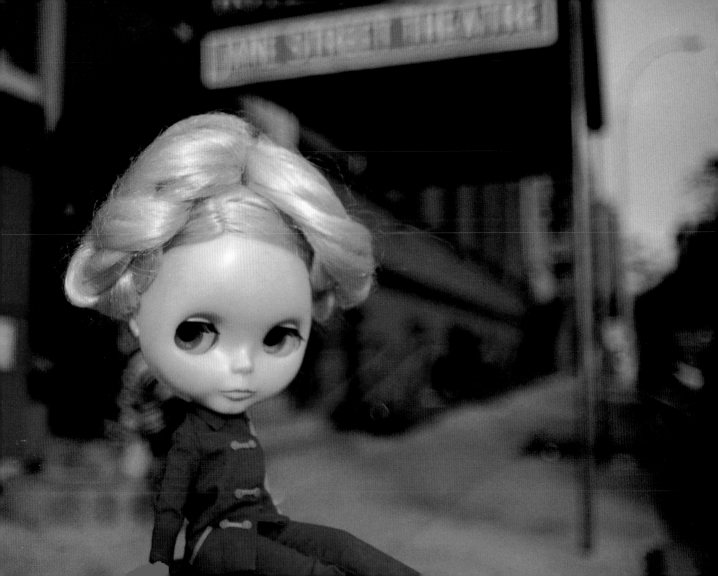

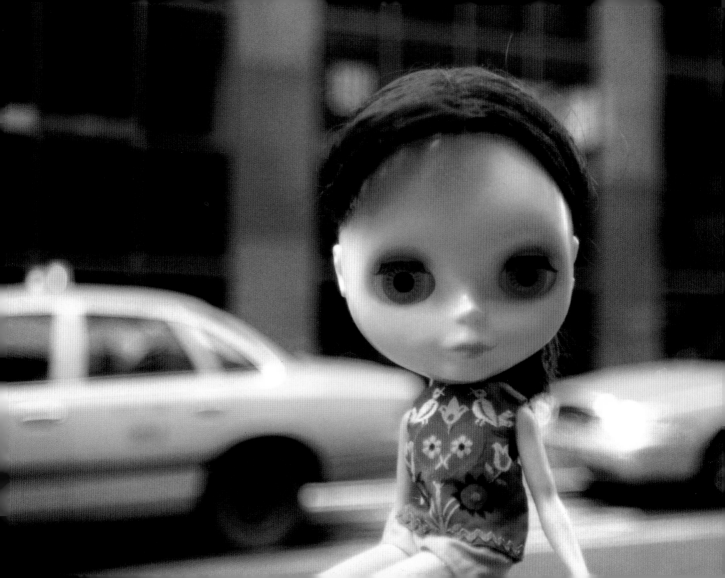

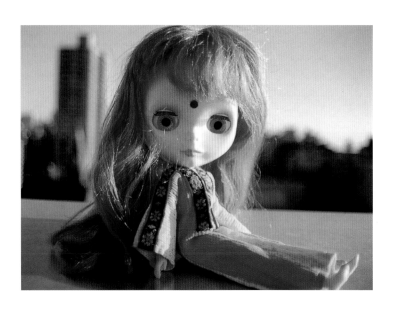

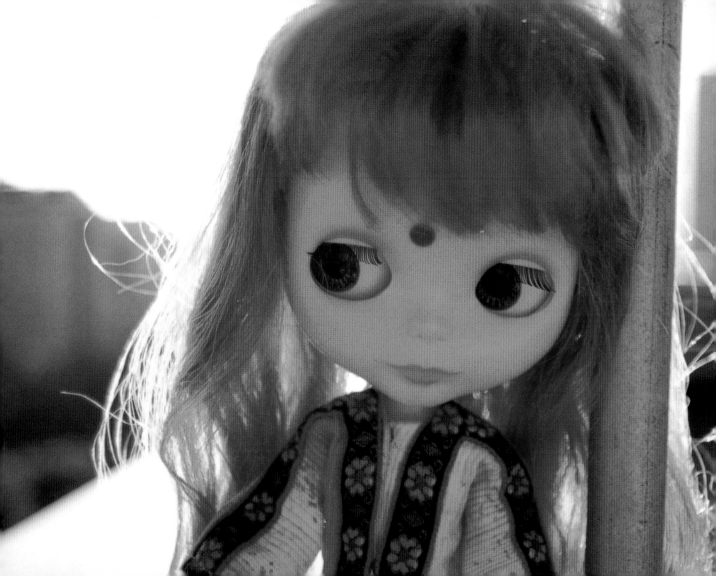

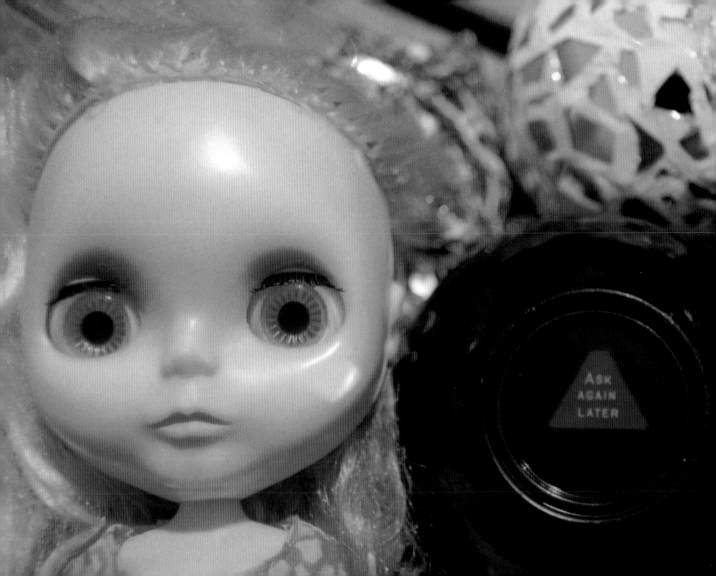

ASK
AGAIN
LATER

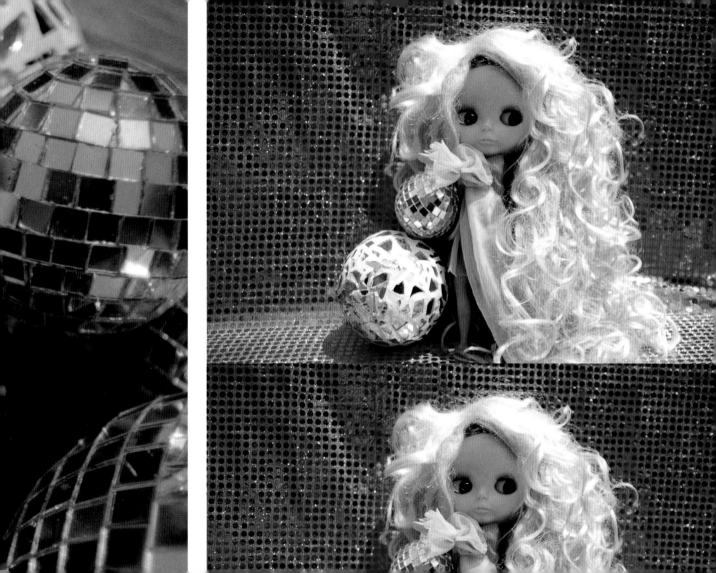

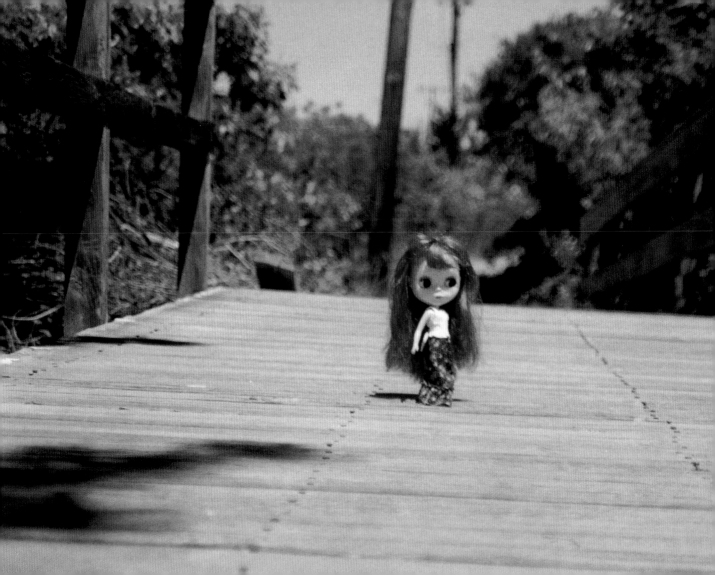

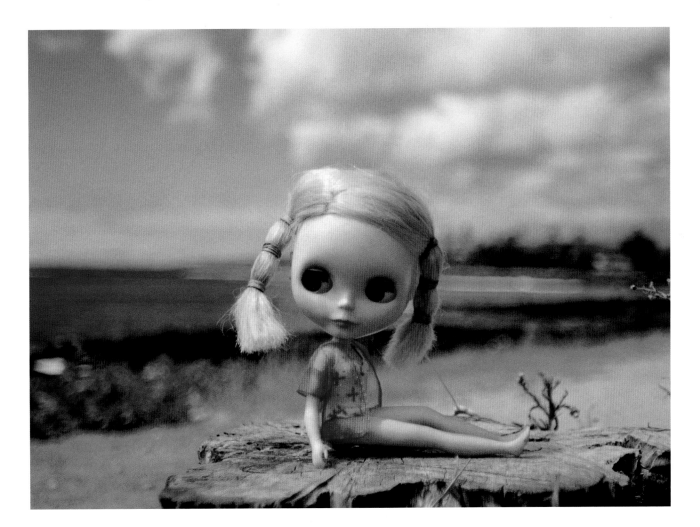

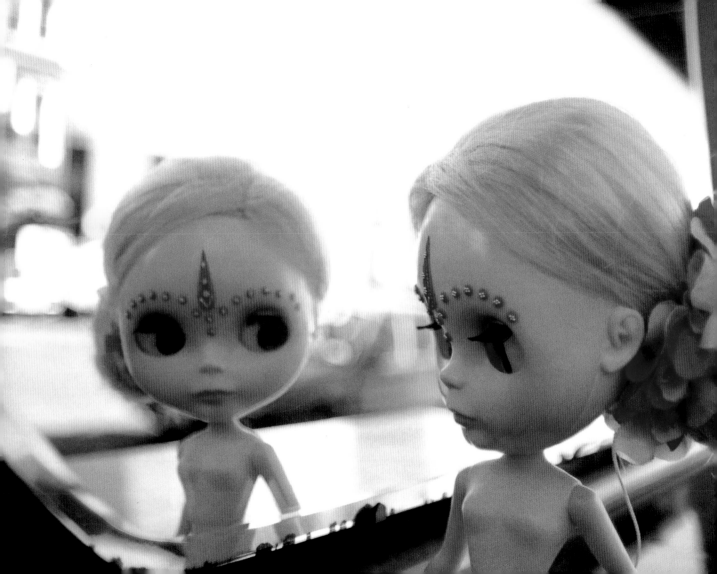

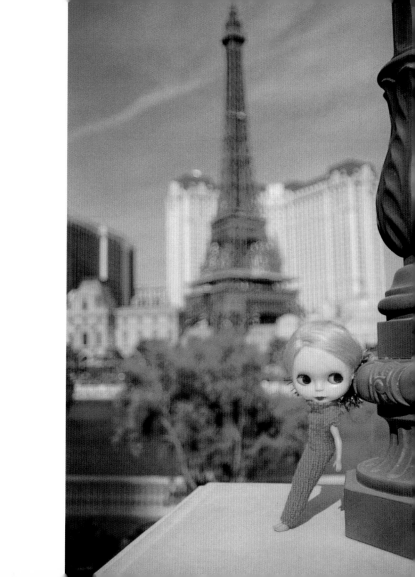

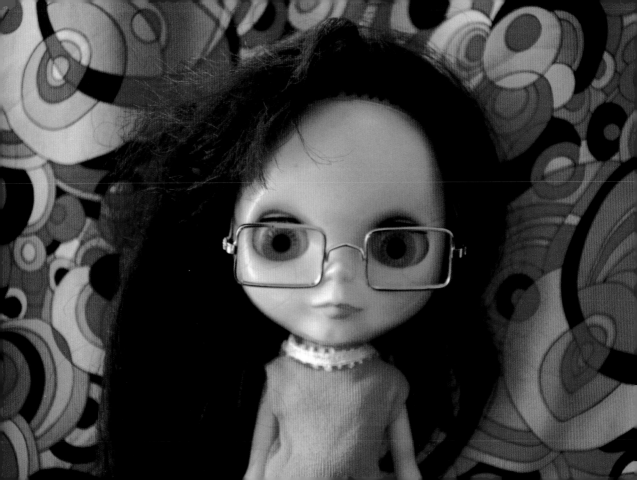

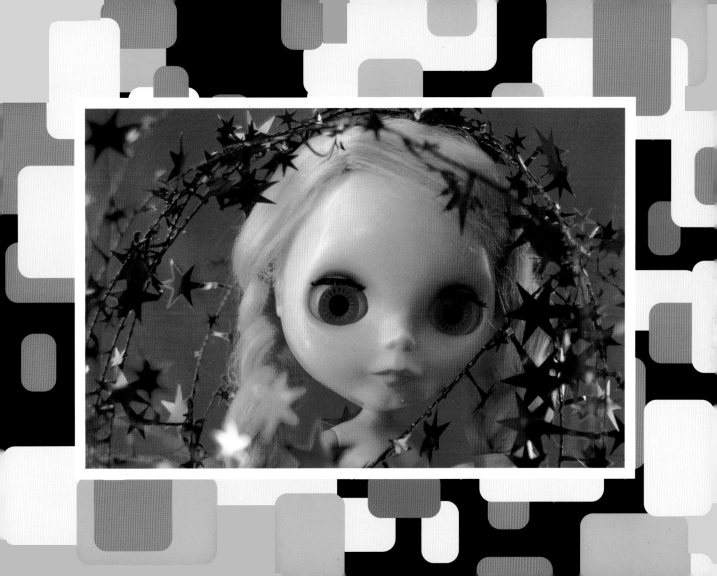

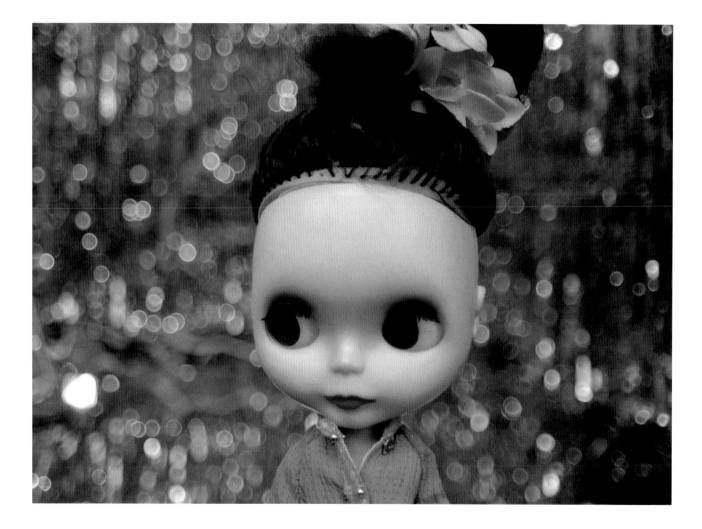

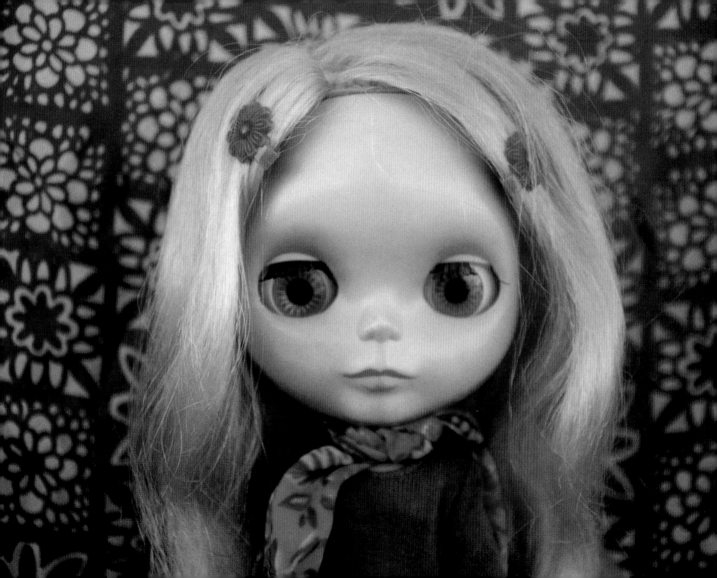

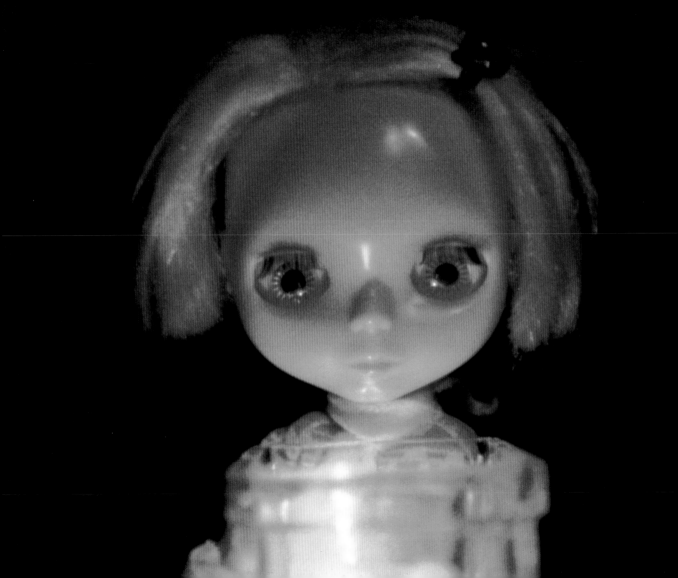

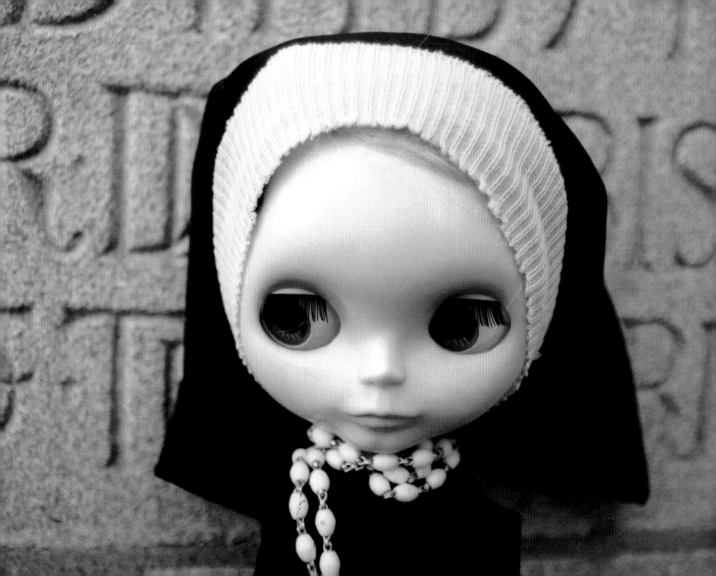

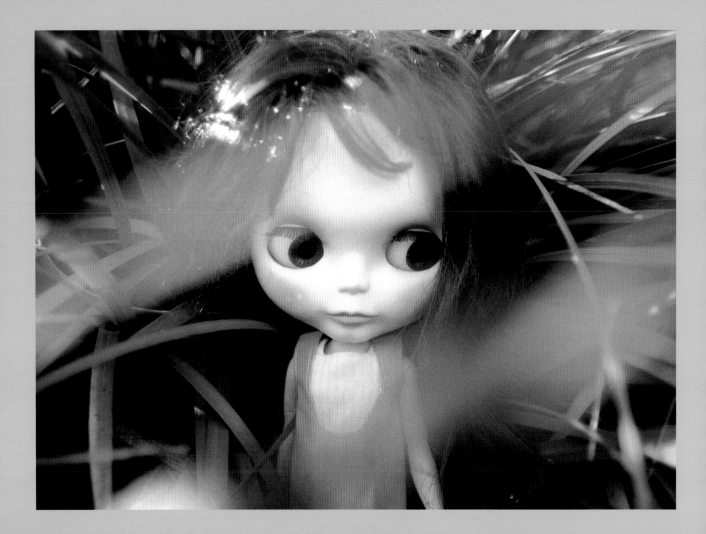

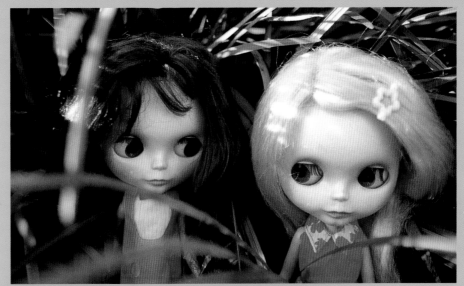

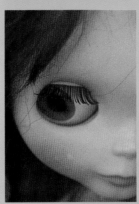

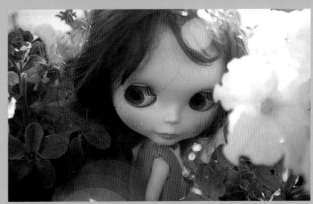

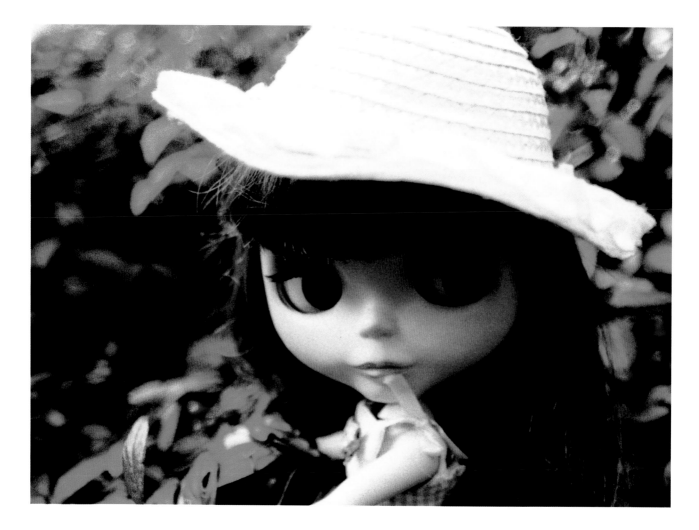

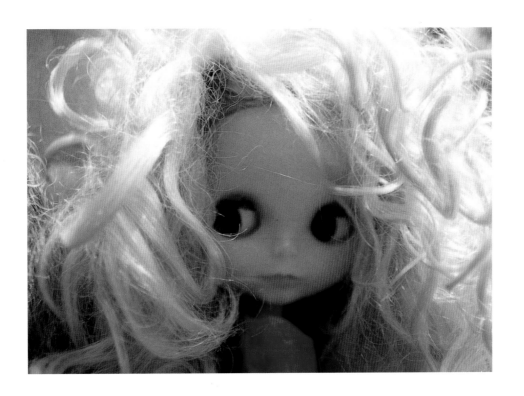

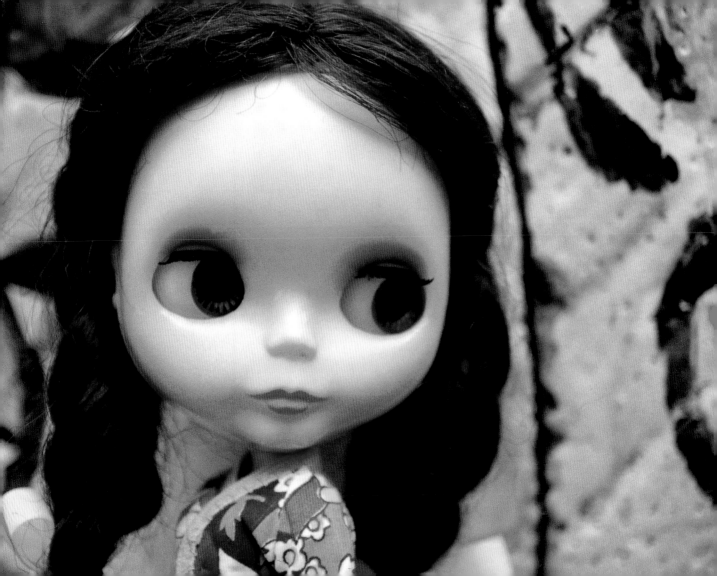

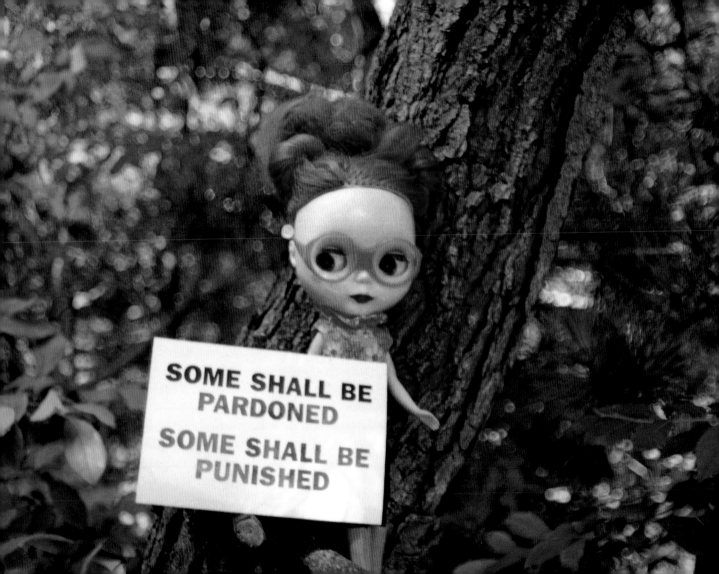

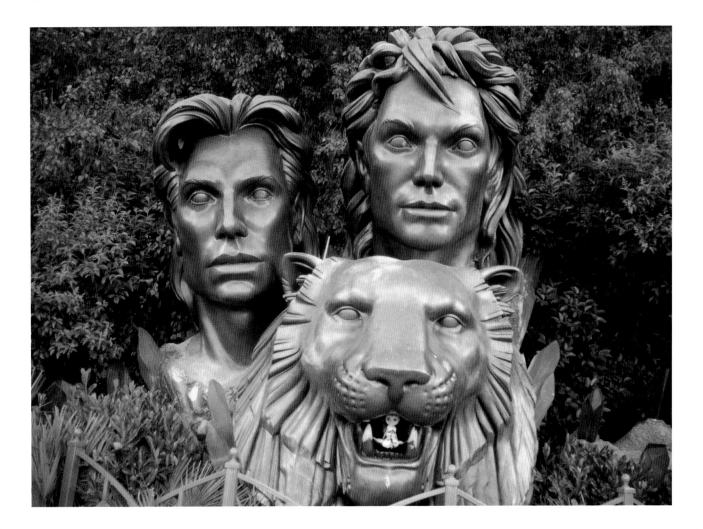

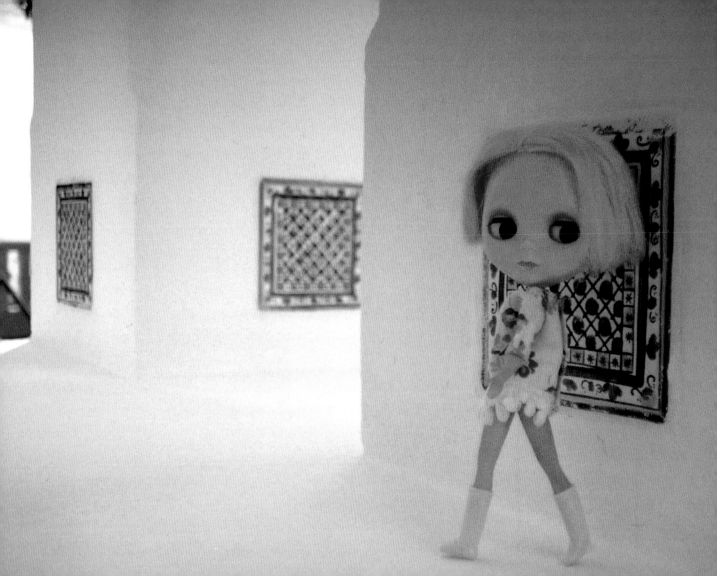

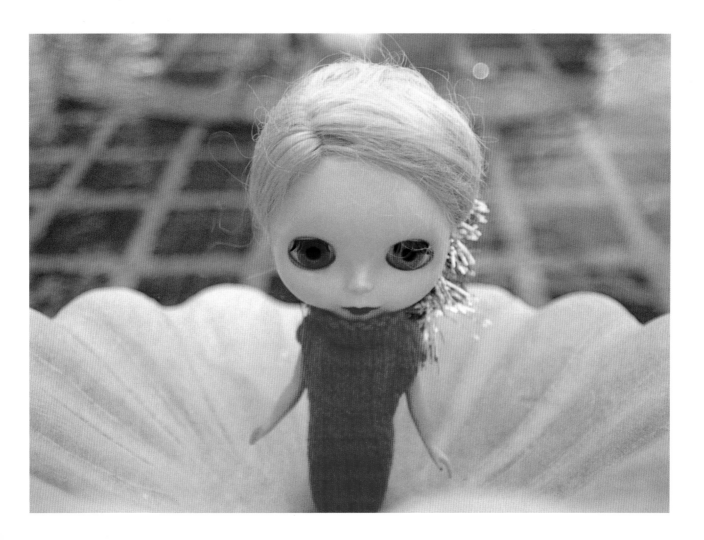

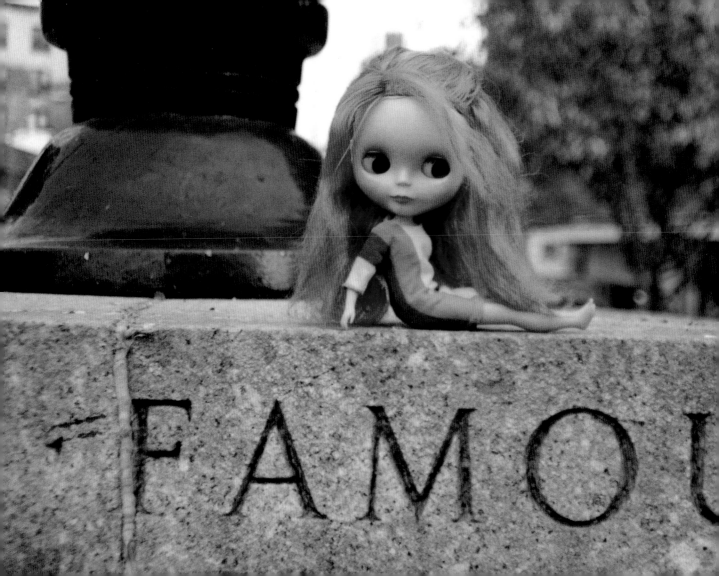

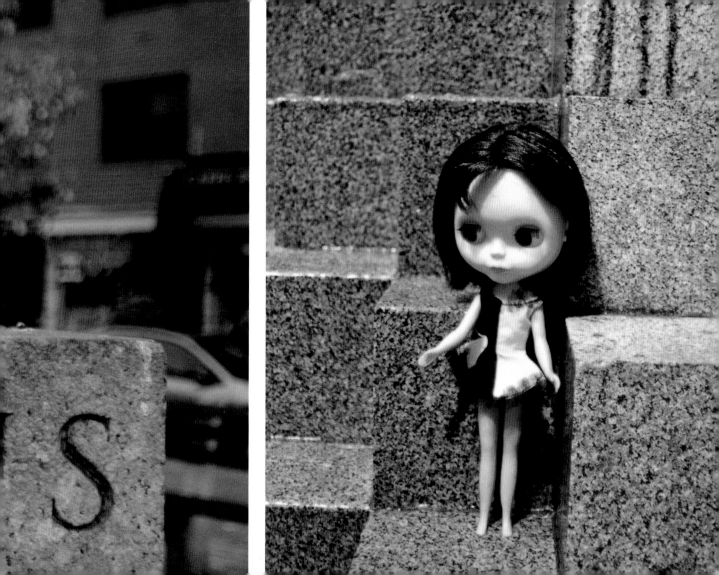

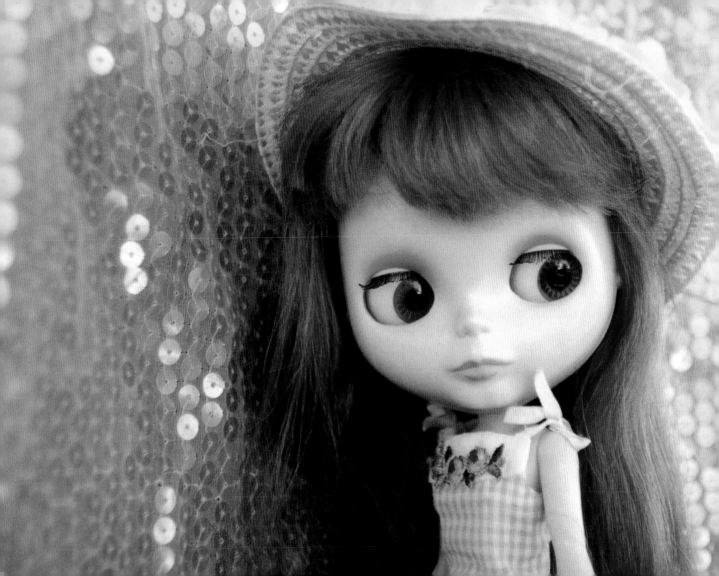

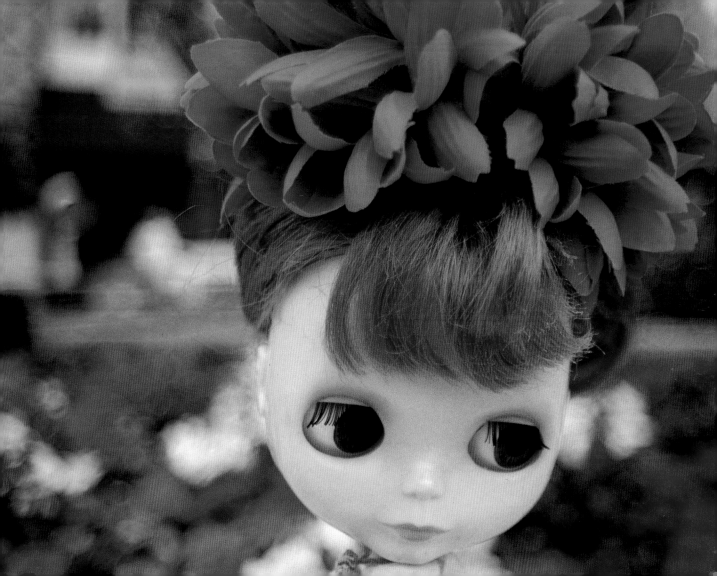

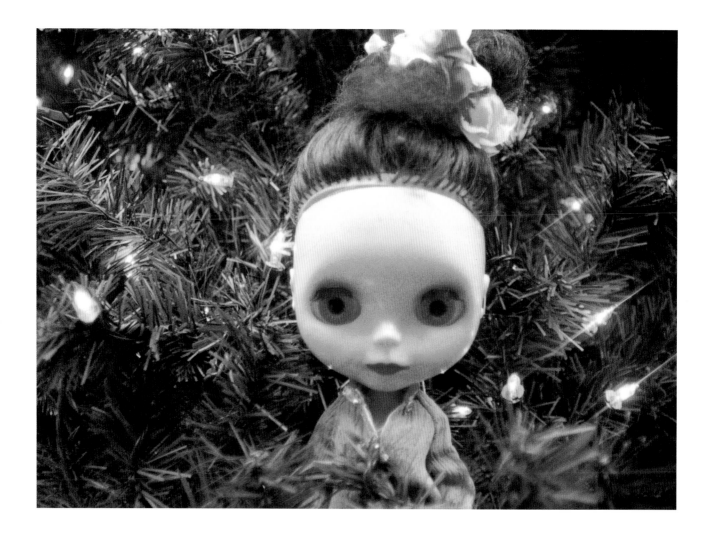

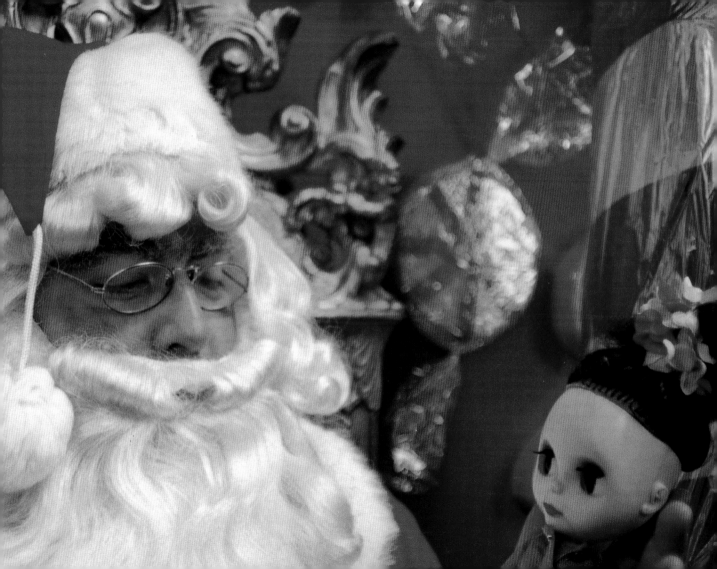

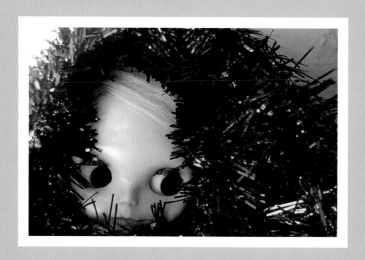

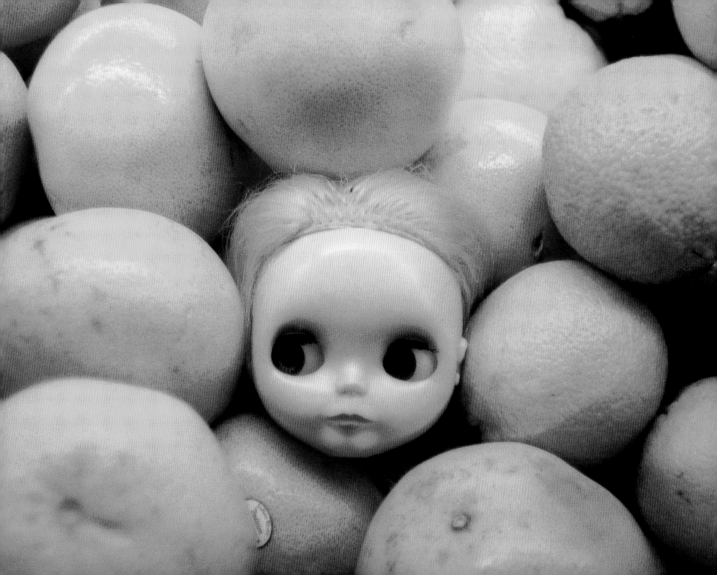

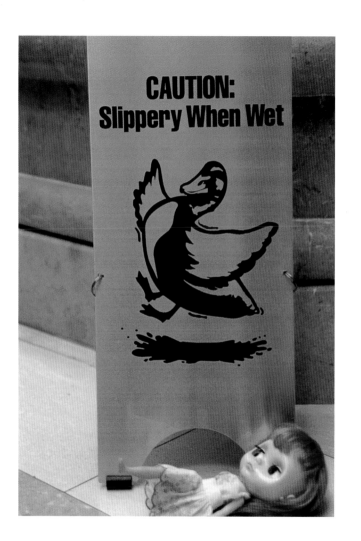

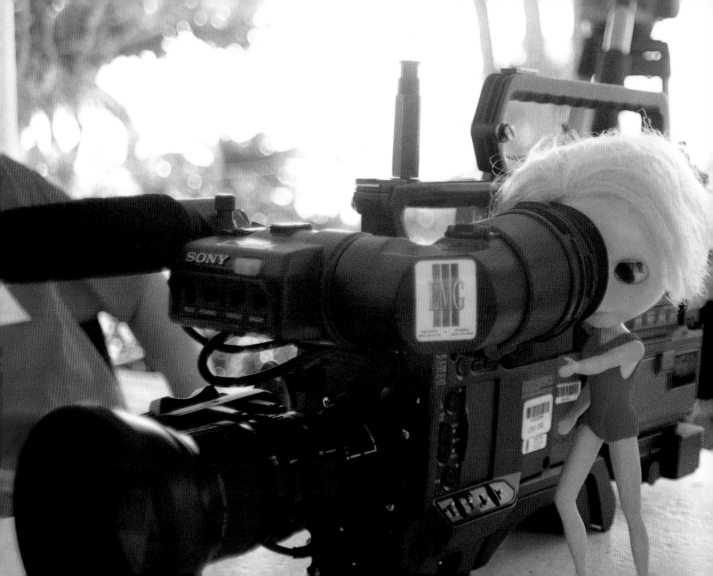

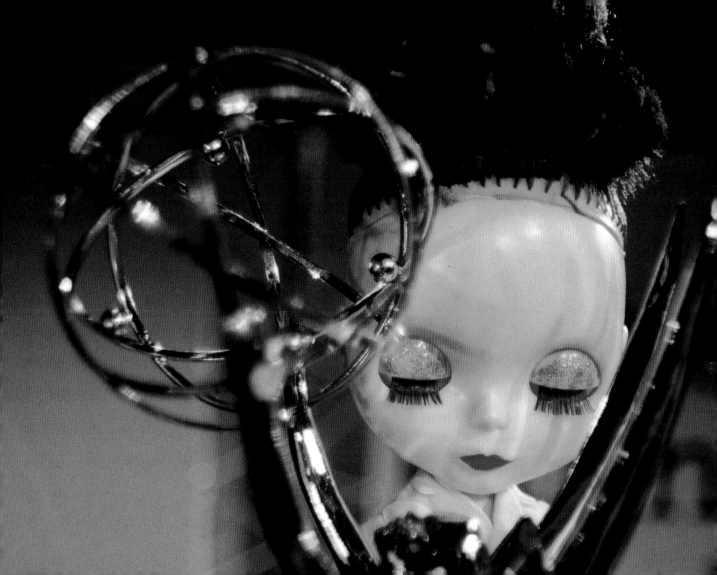

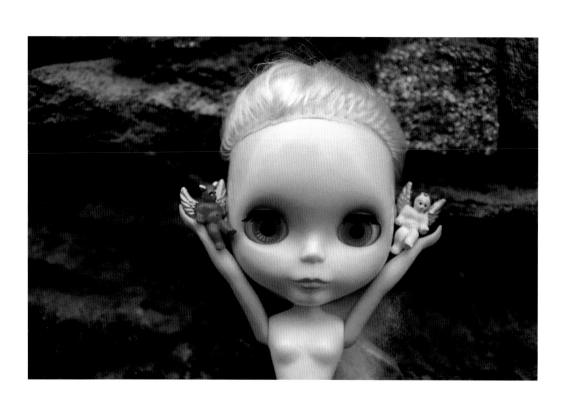

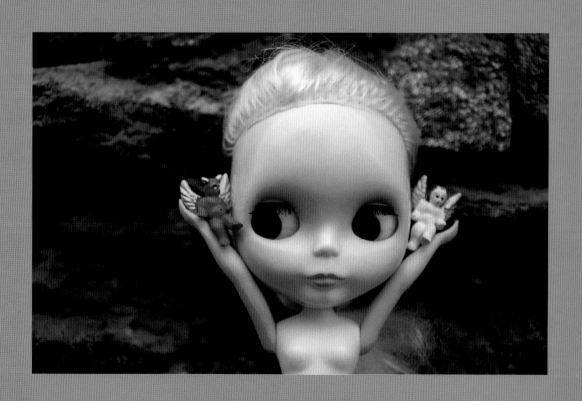

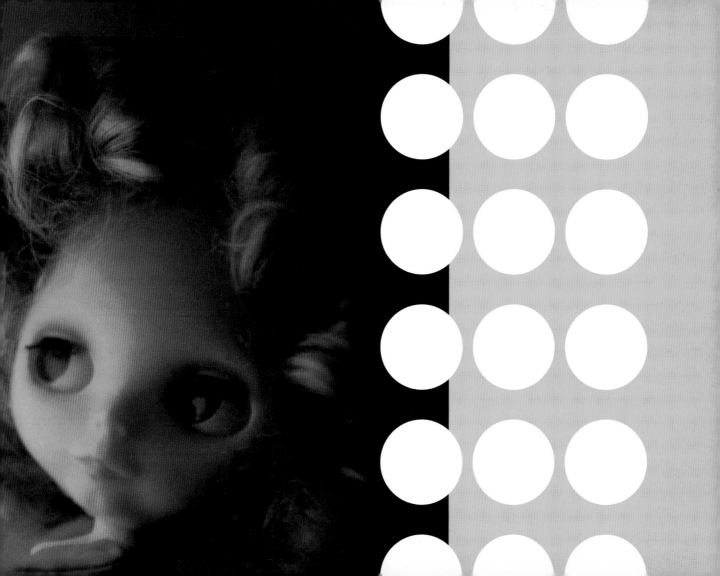

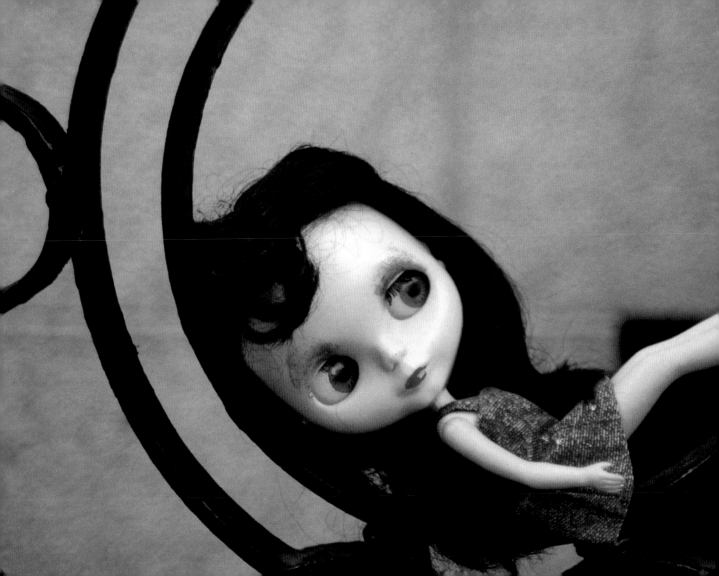

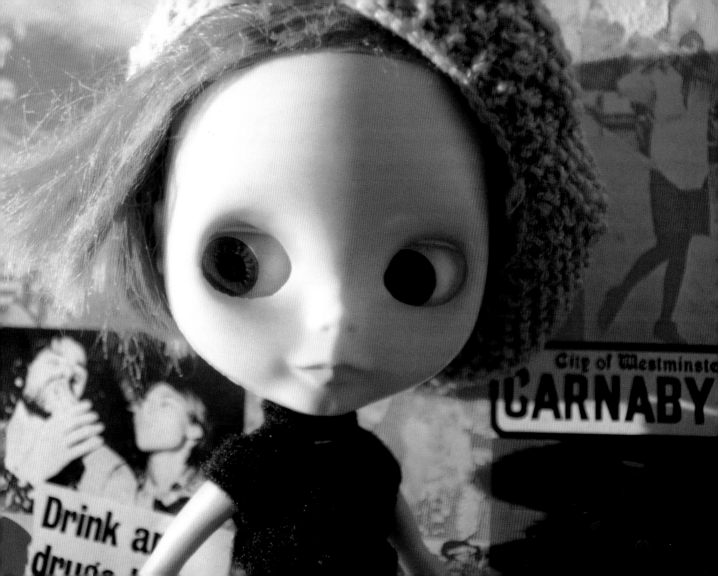

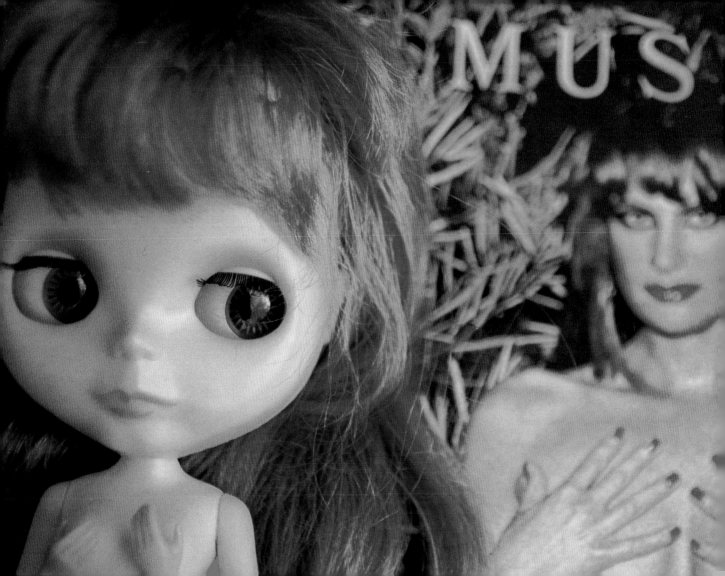

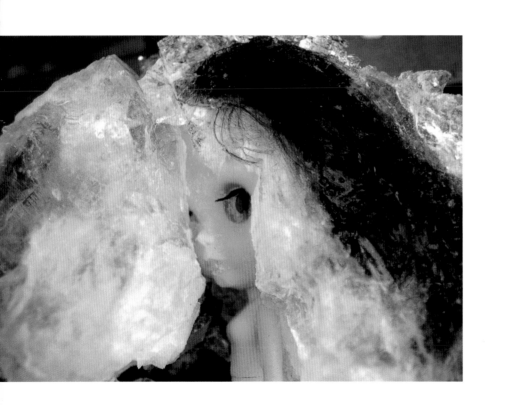

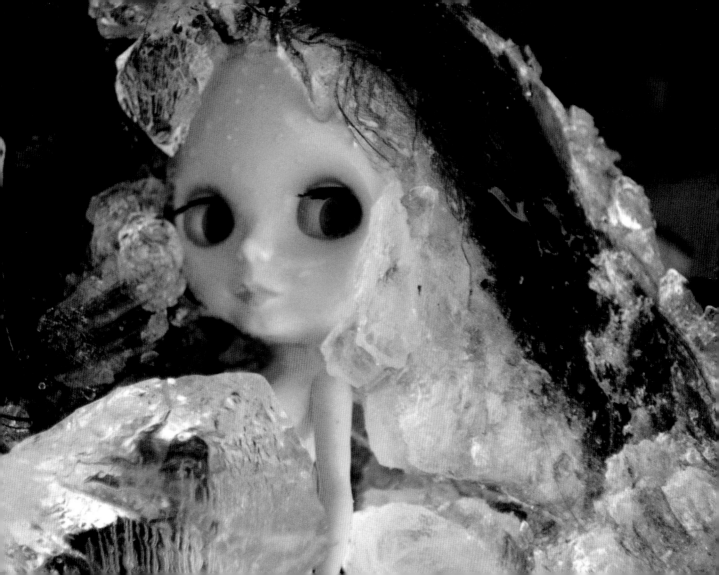

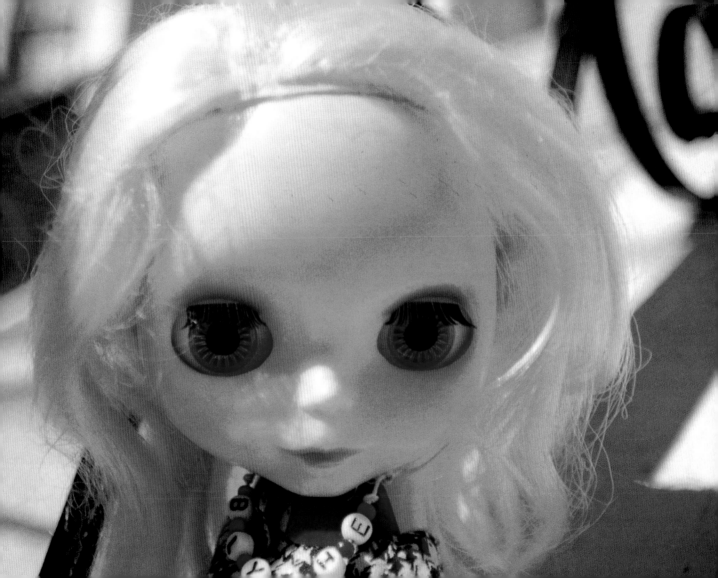

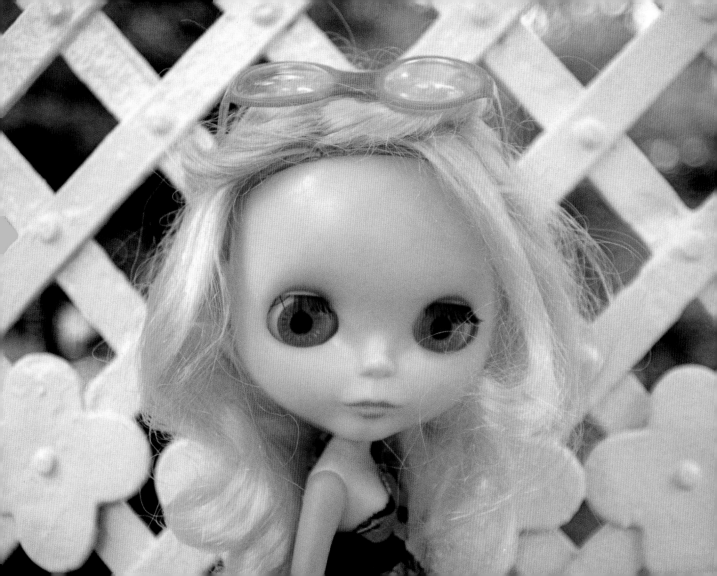

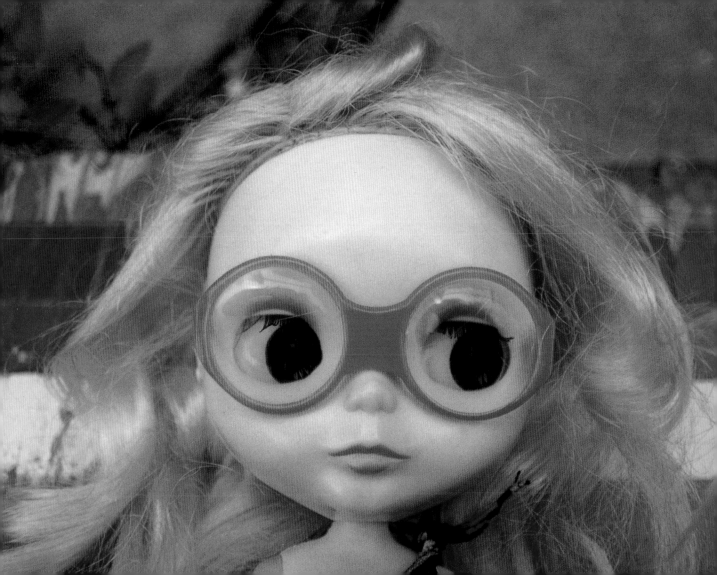

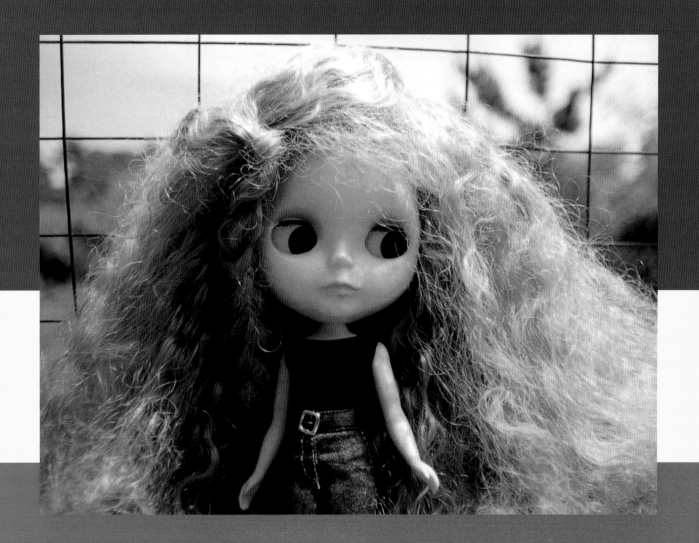

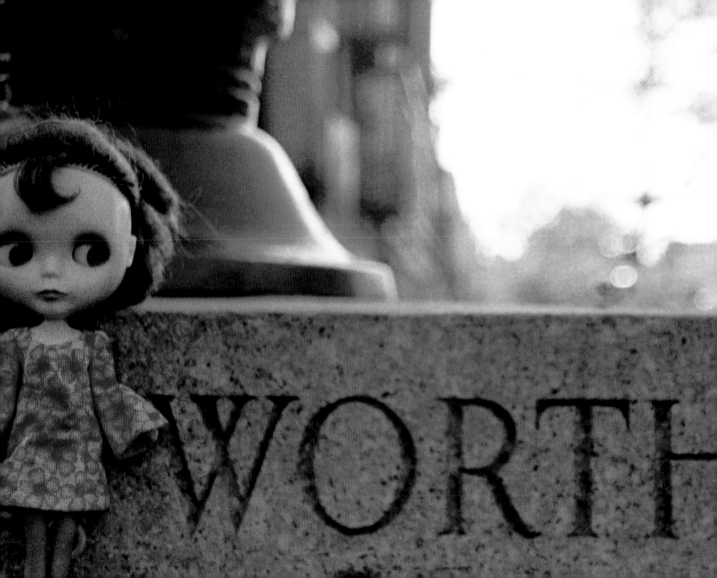

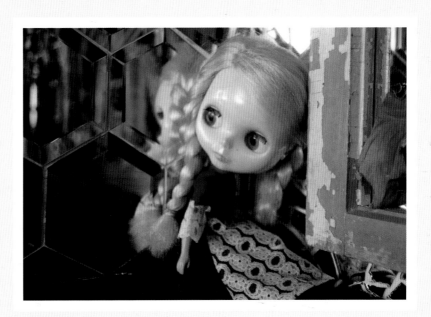

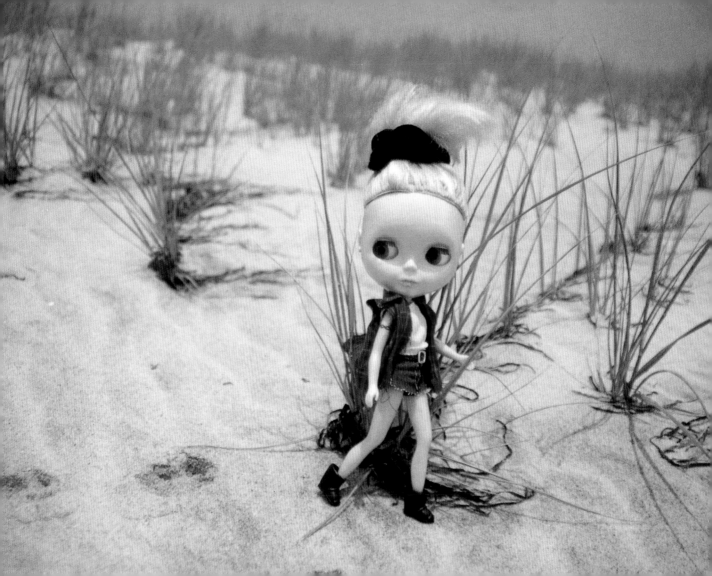

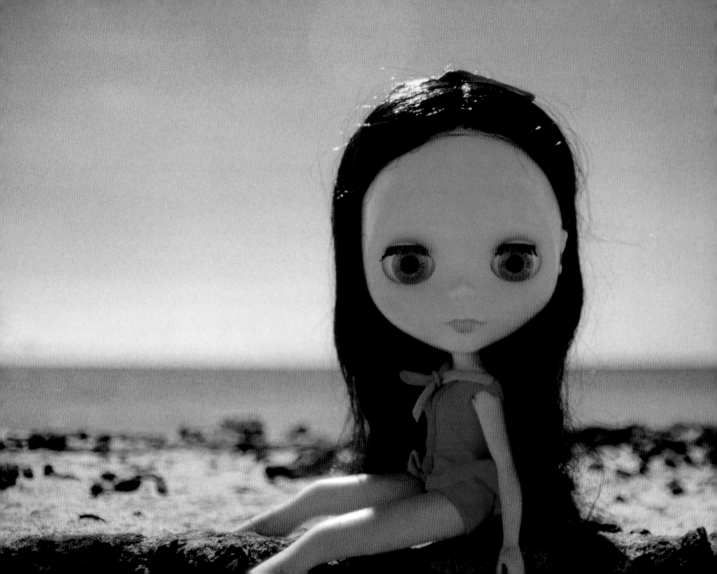

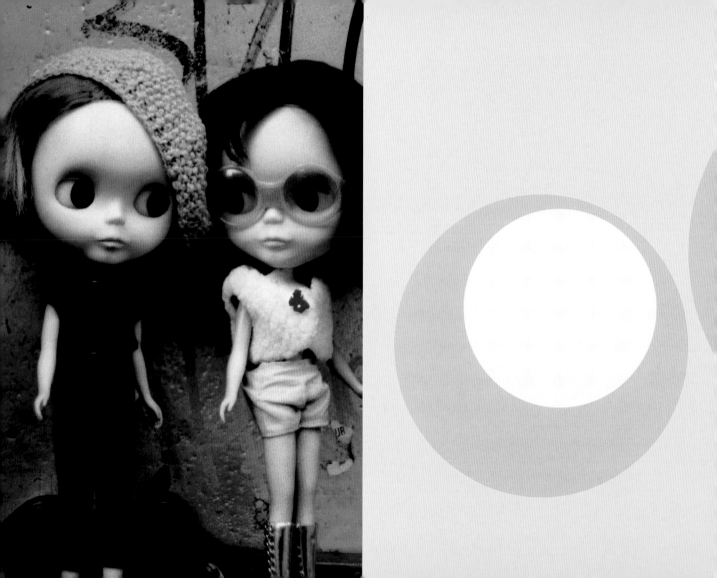

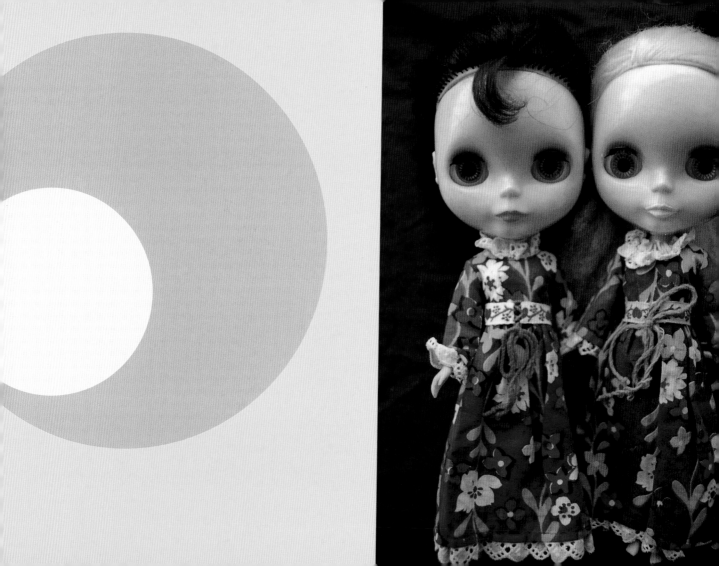

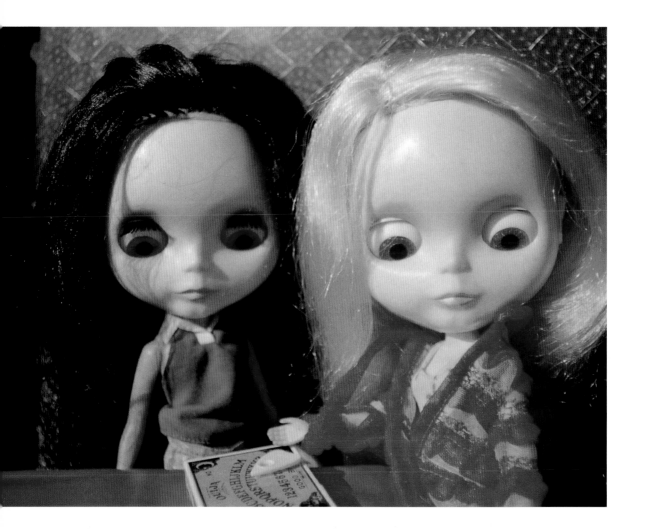

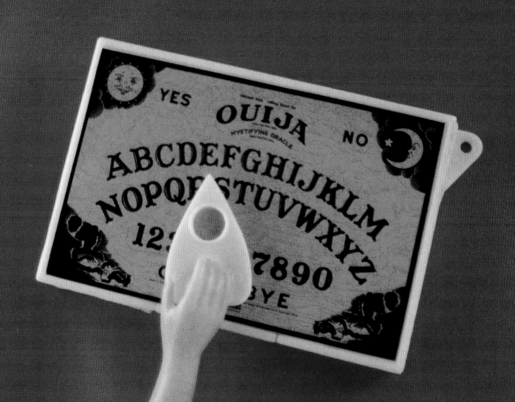

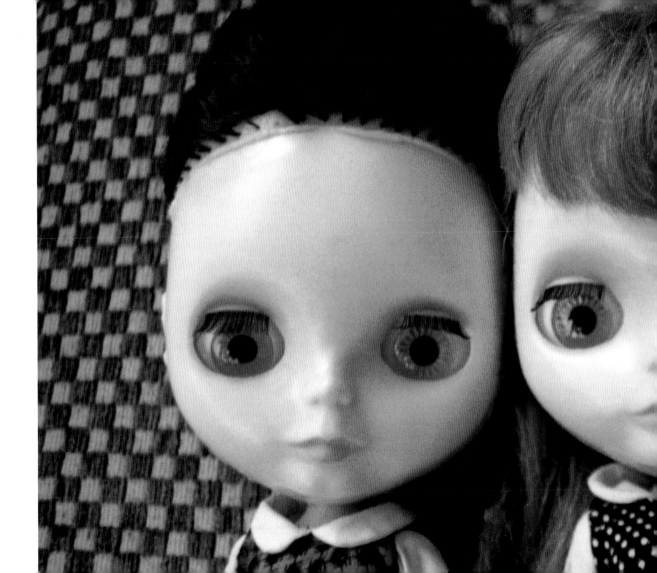

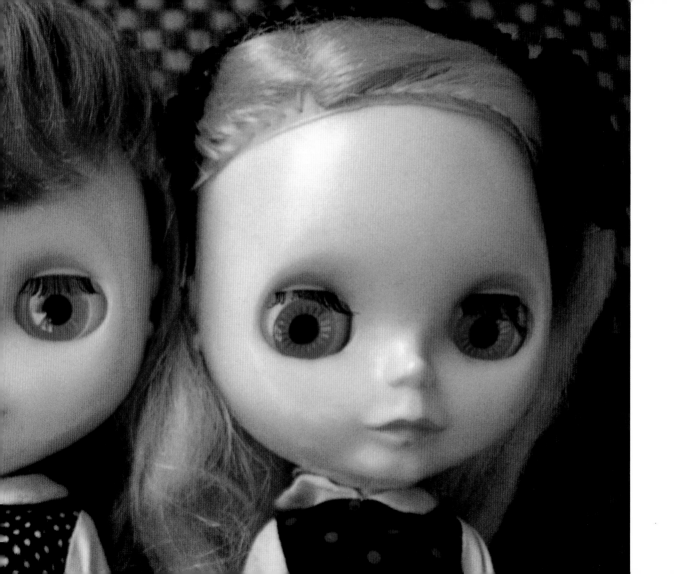

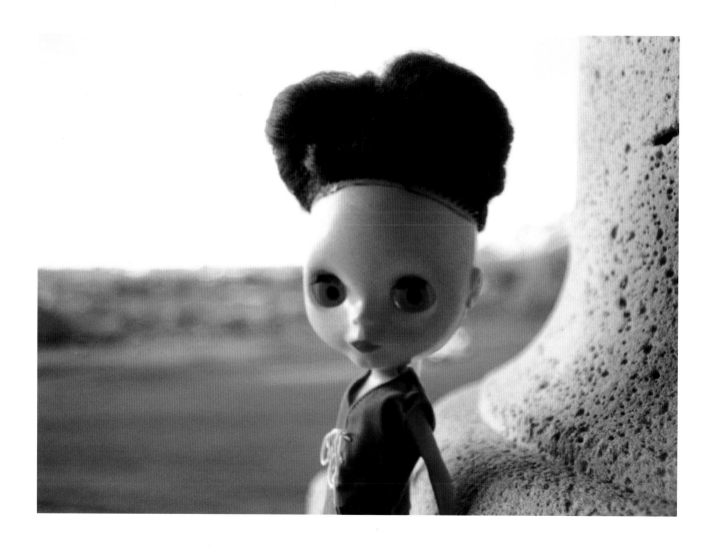

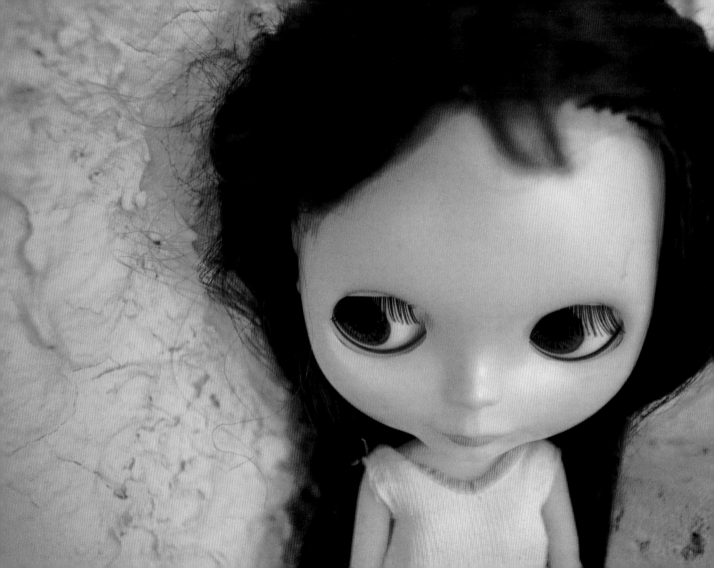

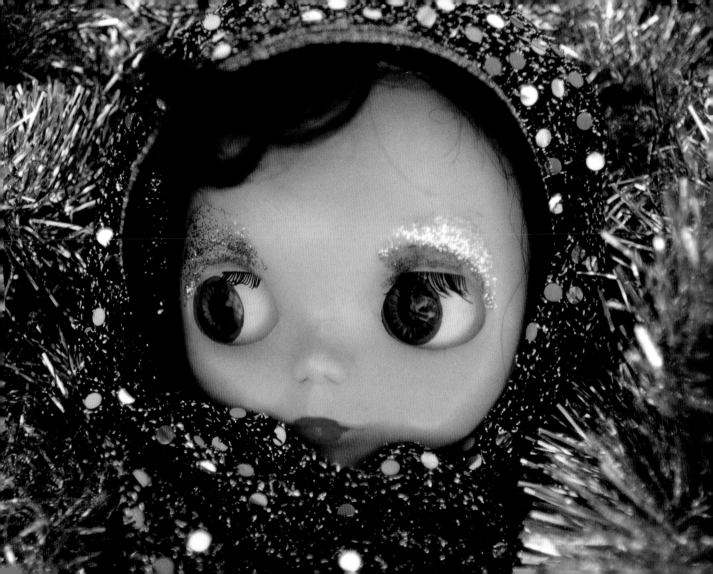

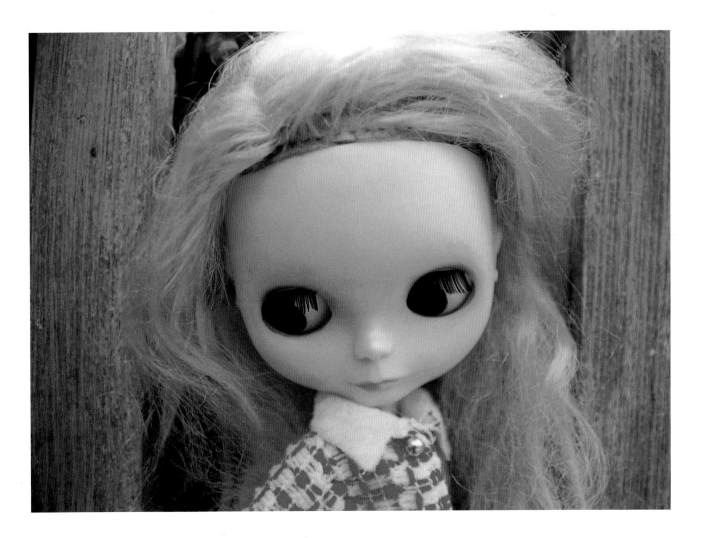

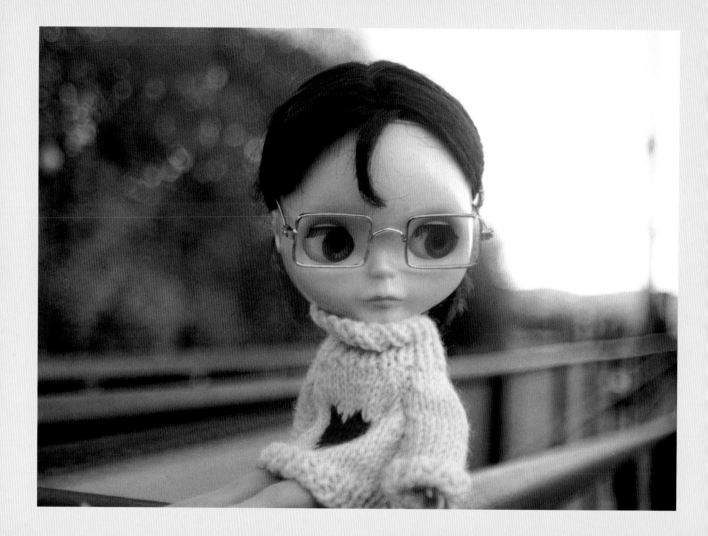

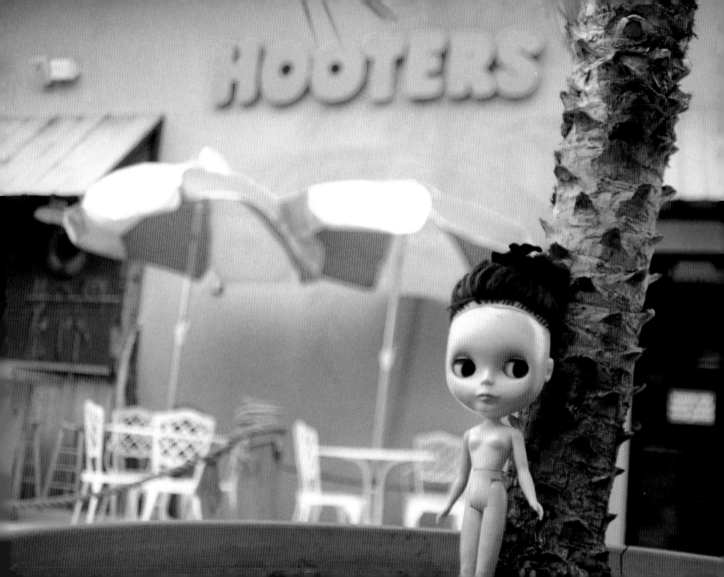

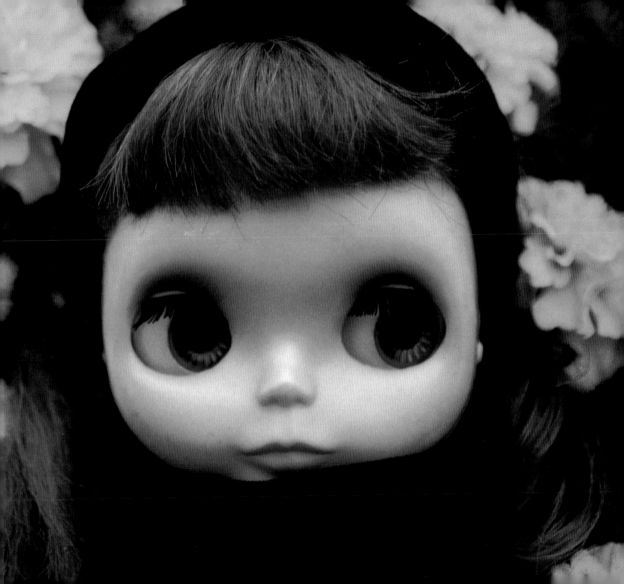

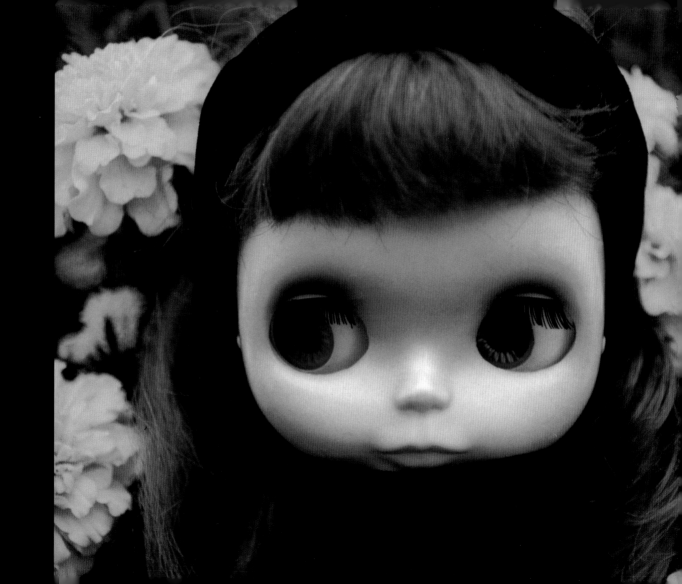

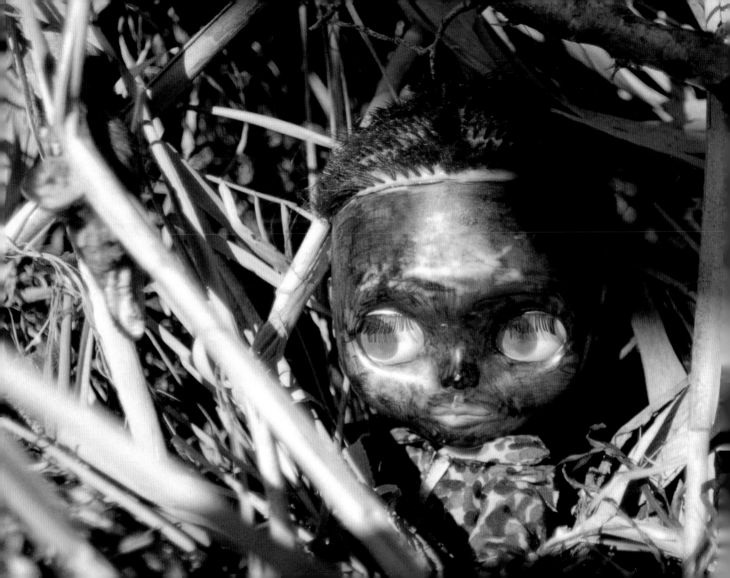

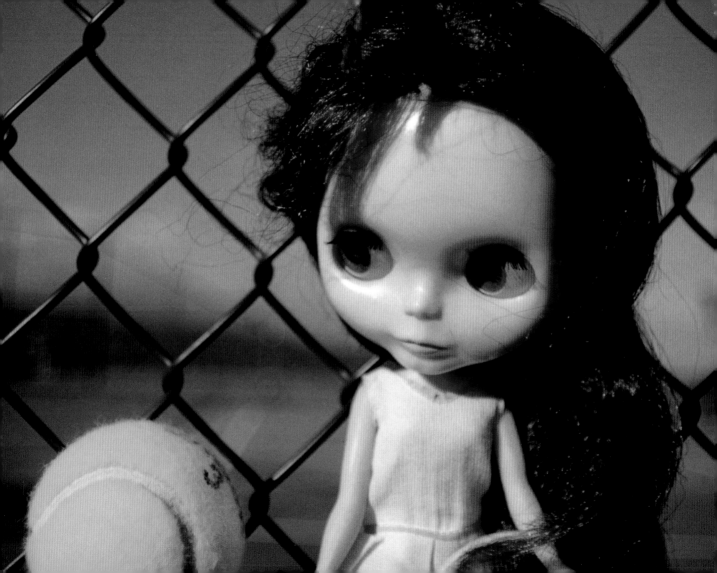

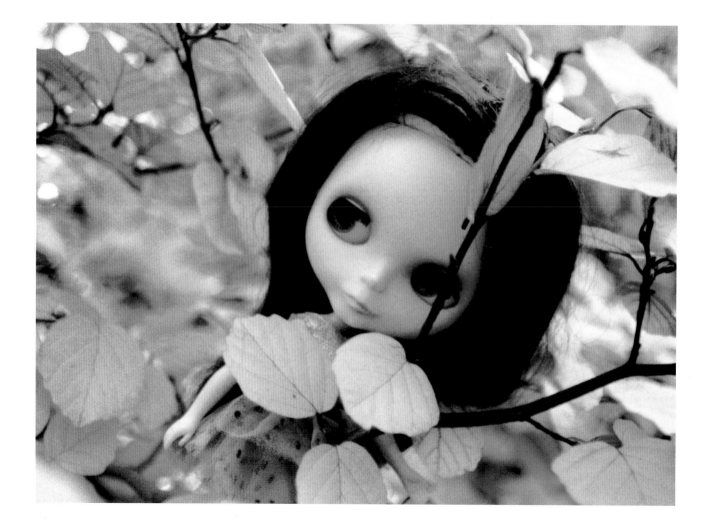

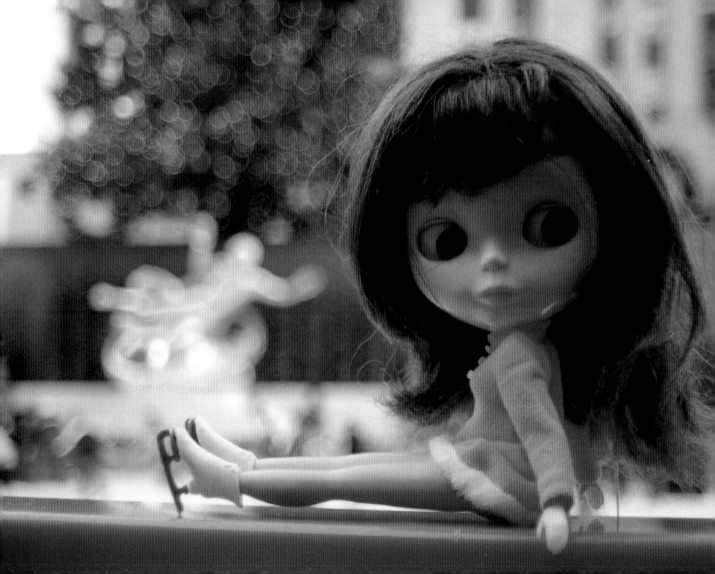

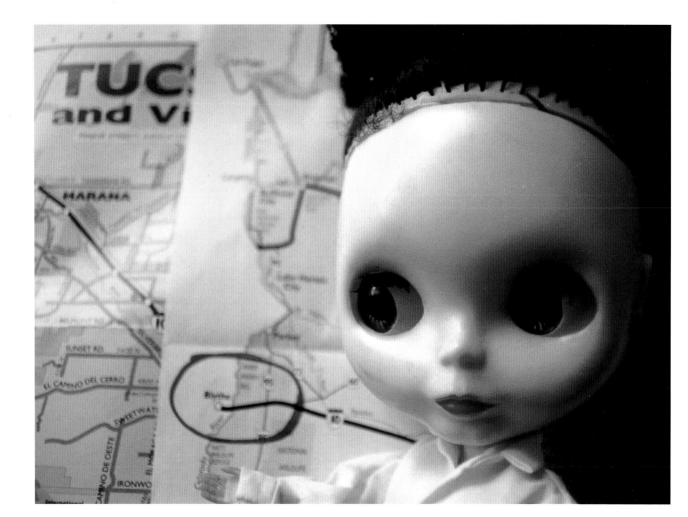